Artist Trading Cards

Leonie Pujol

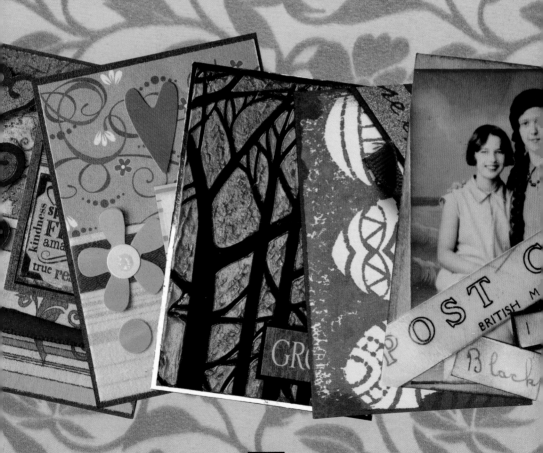

Search Press

First published in Great Britain 2007

Search Press Limited
Wellwood, North Farm Road,
Tunbridge Wells, Kent TN2 3DR

Reprinted 2009

ISBN: 978 1 84448 259 7

The Publishers and author can accept no
responsibility for any consequences arising from
the information, advice or instructions given in
this publication.

Readers are permitted to reproduce any of the
items in this book for their personal use, or for the
purposes of selling for charity, free of charge and
without the prior permission of the Publishers.
Any use of the items for commercial purposes is
not permitted without the prior permission of
the Publishers.

Suppliers

Although every attempt has been made to ensure
that all the materials and equipment used in this
book are currently available, the Publishers cannot
guarantee that this will always be the case. If
you have difficulty in obtaining any of the items
mentioned, then suitable alternatives should be
used instead. For details of suppliers, please visit
the Search Press website: www.searchpress.com

Printed in Malaysia

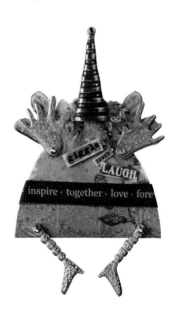

Contents

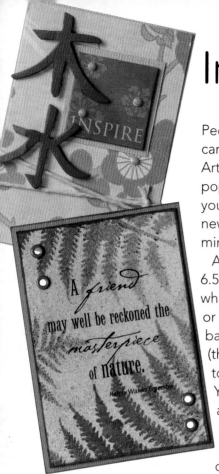

Introduction

People have enjoyed collecting and swapping cards for centuries, so it is not surprising that Artist Trading Cards (ATCs) have become so popular. This new and exciting hobby allows you to explore and develop your creativity, meet new people and share your ideas with like-minded individuals.

ATCs are small cards measuring approximately 6.5 x 9cm (2½ x 3½in). Decorate them in whatever style you choose, using any technique or medium, and put your contact details on the back, then trade or swap them for other cards (they are strictly never sold). Once you start to trade you will find it completely addictive. You will have great fun making the cards, and as your collection grows it will inspire you to develop new designs of your own.

This book provides instructions for twenty different ATCs, using a broad range of techniques and materials. Most of the projects have two variations, showing you how the same techniques can be used to make very different looking cards. It is designed to inspire and stimulate, so let your imagination run free, and above all, have fun!

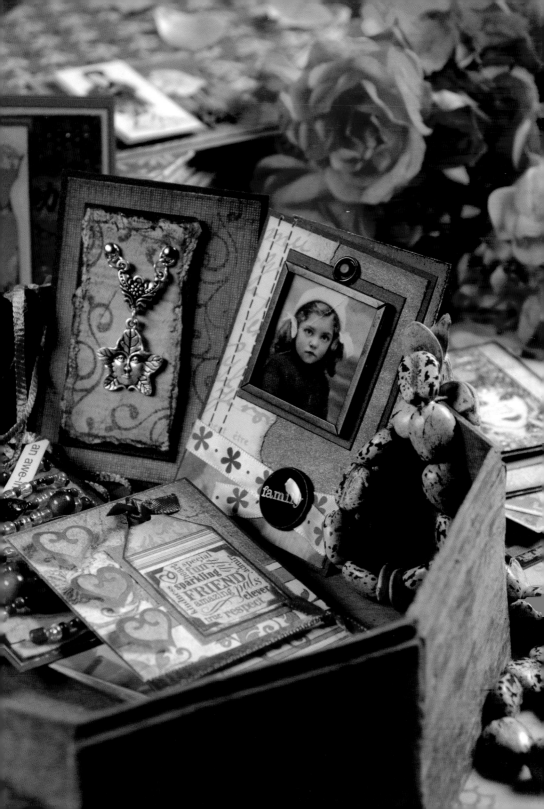

Getting started

I have started with simple but effective Artist Trading Cards, using products that you may already own (but are not expensive if you do not), and styles that can be easily adapted. If you are new to crafting, try to keep your first cards uncomplicated, aim to have a focal image which will give a clean and professional look to your work. Most importantly, have fun and do not worry – there are no right or wrong ways to be creative.

Easily Inspired

Materials:

Chinese die cut words (Topaz Crafts)
'Far East' chipboard sticker stack (DCWV)
Peach textured card
'Fire Blossom' printed textured paper (DCWV)
Fuchsia adhesive stones
Thick cotton thread
Double-sided tape
Silicone glue

Tools:

Scissors
Paper trimmer
Cocktail stick

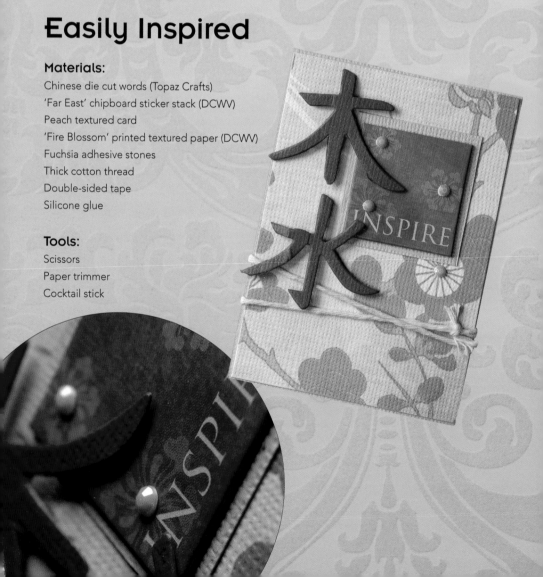

Instructions:

1 Cut a piece of peach card to 6.5 x 9cm (2½ x 3½in). Cut the Fire Blossom paper slightly smaller and attach the two together using double-sided tape.

2 Attach the 'Inspire' chipboard sticker to a small piece of peach card and cut round it leaving an even border. Attach it to the top right-hand corner of the card with double-sided tape.

3 Wrap the thread around the lower part of the card twice, below the 'Inspire' sticker, and secure it with a double knot.

4 Attach the Chinese die cuts to the left-hand side of your card using small amounts of silicone glue applied to various parts of the die cuts. I used a cocktail stick to apply the glue. Place the die cuts on to the card, allowing them to overlap the 'Inspire' sticker. (Silicone glue allows you to create movement by tilting the die cuts at different angles; 3D foam pads can be used, but these give a flatter three-dimensional effect.)

5 Finish the card with adhesive stones applied to the centres of the flowers.

Variations

Pretty Daisy
I have cut the daisy from coordinating cardstock and used this as my focal point by attaching it to layers of card using silicone glue. I have positioned the phrase sticker so that it runs down the side of the card. A ribbon is added to give a finishing touch.

Friends Tag
Use coordinating vintage papers and tag to make this ATC. Cut the heart die cuts from the coordinating papers and attach them to the left-hand side of the card using silicone glue. The red ribbons bring the card to life.

7

Decoupage creations

Decoupage is the art of building up images in layers to create a three-dimensional effect. Pre-printed sheets are available in a wide range of styles and levels of complexity. Use either 3D foam pads to attach the layers, or silcone glue. The latter is less rigid and allows you to position the layers at different angles.

Chinese Panda

Materials:
'Panda' decoupage sheet (Marij Rahder)
Cream card cut to 6.5 x 9cm (2½ x 3½in)
Black permanent pen
3D foam pads or silicone glue
Glue dots

Tools:
Scissors
Paper trimmer

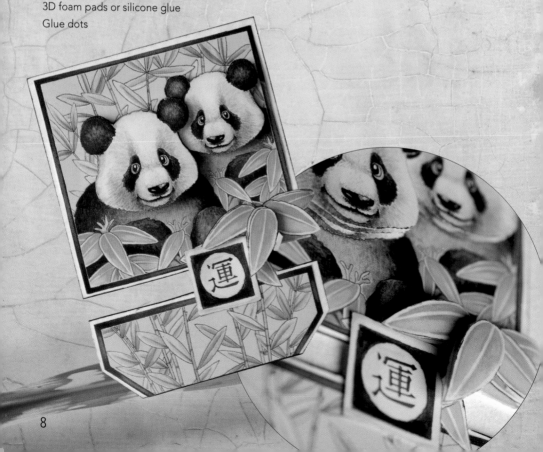

Instructions:

1 Cut out the pieces of decoupage, together with the Chinese symbol square, and arrange them from the largest to the smallest.

2 Attach the largest piece of decoupage to your ATC card using glue dots. Trim off any parts which overlap the edge of the card and cut out the lower section and bottom corners (these are the blank parts on the printed picture). This will add interest to your ATC.

3 Build up the decoupage picture using 3D foam pads or silicone glue.

4 Attach the Chinese symbol to the central part of the picture.

5 Edge the card carefully with the black pen.

Variations

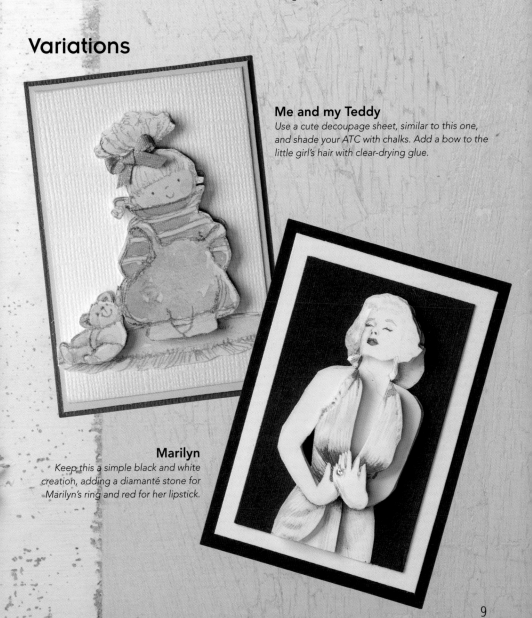

Me and my Teddy
Use a cute decoupage sheet, similar to this one, and shade your ATC with chalks. Add a bow to the little girl's hair with clear-drying glue.

Marilyn
Keep this a simple black and white creation, adding a diamanté stone for Marilyn's ring and red for her lipstick.

Creative backgrounds 1

There are many different media available to create fabulous backgrounds; try experimenting with stamping, chalks, paints, colour washes – even your old tea bag! For these cards I have used alcohol inks. They can be applied to non-absorbent surfaces, blend wonderfully and dry quickly.

Where there is Love there is Life

Materials:

Lilac pearlescent card cut to 6.5 x 9cm
(2½ x 3½in)

Silver mirri card

Coordinating 'Where there is Love there is Life' sticker, flower and purple paper (Deja View)

Silver brad

Stream, Bottle and Wild Plum alcohol inks (Tim Holtz)

Silver metal sheet

Double-sided tape

3D foam pads

Inkpad

Tools:

Scissors

Paper trimmer

Pricking tool

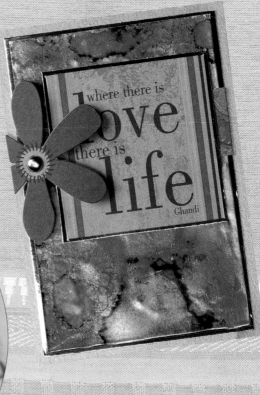

Instructions:

1 Cut a piece of silver mirri card down so it is slightly smaller than the lilac pearlescent card, and attach the two together with double-sided tape.

2 Cut the metal sheet down so you have a piece slightly smaller than the mirri card.

3 Make a felt pad by attaching a piece of felt to the lid of an inkpad using double-sided tape. Cover the metal sheet with several drops of each colour of alcohol ink, then use your felt pad to blend the colours together. Practise with lighter and firmer dabs to achieve different effects.

4 Allow the ink to dry, then attach the metal sheet to the card using double-sided tape.

5 Cut out a thin piece of purple paper and attach it to the right-hand side of the card using double-sided tape.

6 Attach the sticker to a piece of silver mirri card and cut round it leaving a thin border. Attach this to the card with double-sided tape.

7 Make a hole in the centre of the flower using the pricking tool and attach the silver brad. Attach the flower to the card using a 3D foam pad, allowing the flower to overlap off the edge of the card. Trim off the overlapping parts of the flower.

Variations

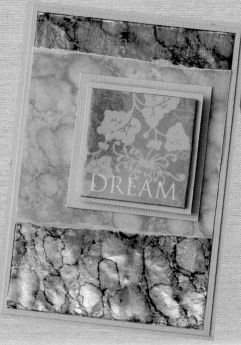

Dreams

To create this card I used a combination of Stream and Denim alcohol inks. I blended them using blending solution applied directly to a felt pad and then dabbed on to the metal sheet. To complete the card I applied a piece of vellum which allows the inks to show through, then attached a chipboard sticker matted and layered on coordinating coloured cardstock.

The Red Dress
For this ATC I used Red Pepper and Butterscotch alcohol inks, applied in the same way as for the main card. I created texture on the silver metal sheet by smoothing it over a sheet of mesh. I then attached a beautiful Chinese dress in the form of a clear-backed sticker matted and layered on coloured card, and a Chinese word sticker.

Creative backgrounds 2

For the cards below, I have used Pattern Builder – a wonderfully versatile product used to create texture and movement. Apply it with a lollypop stick or spatula, then either smooth over the surface, or use sponges, combs, bubblewrap, or whatever comes to hand to create texture. Pattern Builder dries clear, but can be mixed with paints and powders for different effects.

Passing Time

Materials:

Pattern Builder

Blank ATC card

Plain piece of scrap card

'Memories' Artist Trading Card kit (Crafty Bitz)

'Time' transparency TC03 (Crafty Bitz)

Black brads (Papermania)

Cranberry acrylic paint dabber (Adirondack)

Snowflake cut in black from 'Snowflake' die cut (Quickutz) (Alternatively, you can buy ready-made clock hands, or cut them out freehand from black card.)

Black solvent-based inkpad

Glue dots

Double-sided tape

Tools:

Scissors

Lollypop stick

Pricking tool

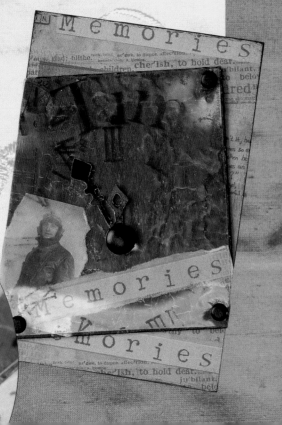

Instructions:

1 Spread the Pattern Builder on to the scrap card using a lollypop stick, creating smooth and bumpy areas. Leave it overnight to dry.

2 Apply the acrylic paint unevenly and allow it to dry.

3 Tear the word 'memories' from the 'Memories' paper in the ATC kit. Attach the remaining paper to the blank ATC card (the top part at the top of the card and the bottom part at the bottom) using glue dots.

4 Cut the Pattern Builder card down so that it is smaller than the ATC and attach the word 'memories' and the airman image to it using glue dots.

5 Attach the 'Time' transparency to the Pattern Builder card using brads and cut down the snowflake so that it looks like clock hands. Attach them with a large brad. Edge the card with black solvent-based ink.

6 Attach the Pattern Builder card to the ATC at an angle using double-sided tape.

7 Go round the edge of the ATC with the acrylic paint and the black ink.

Variations

Harmony
Use the Pattern Builder again, but this time when it is dry cut the card down to ATC size and apply pearlescent acrylic paint, which will dry with a beautiful sheen.

Asian Art
This time I have stamped the image of the Asian lady using black solvent-based ink and coloured it in, then applied Pattern Builder over the top. While the Pattern Builder was still wet, I dusted it with pigment powders and left it to dry. Pattern Builder dries clear so you are able to see your stamped image underneath the texture.

Stamping 1

For this section I have created ATCs using rubber stamps. There are so many stamps on the market, and ways to use them, it's difficult to know where to start (and when to stop!). On this page I have demonstrated how stamping twice and decoupaging part of the image can create depth and interest to your finished card.

Life is Beautiful

Materials:

Cream card cut to 6.5 x 9cm (2½ x 3½in)
Cream scrap card
White scrap card
Black solvent-based inkpad
Brown decorative chalk
Watercolour pencils
Gold glitter glue
Small piece of red card
Acrylic stamping block
'Puzzle' stamp set CSET03 (Magenta)
3D foam pads
Glue dots

Tools:

Scissors
Paper trimmer
Cotton wool ball

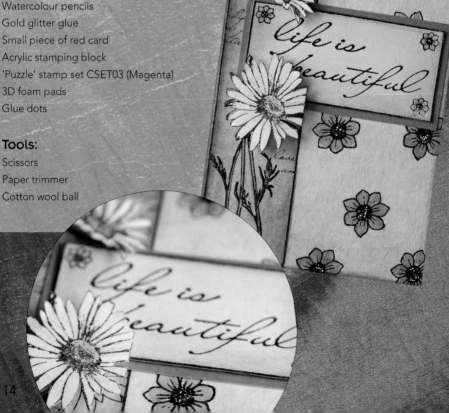

Instructions:

1 Attach the daisy stamp to the acrylic block and ink it with black solvent-based ink. Stamp the image once on to the left-hand side of your ATC, re-ink, then stamp it on to the white scrap card (you only need to transfer the daisy heads).

2 Using the small flower stamp, stamp the flower randomly over the right-hand side of the ATC.

3 Ink up the 'Life is Beautiful' stamp and stamp it once on to the cream scrap card. Trim around the black border and cut a piece of red card slightly larger than the stamped image. Attach the two together using glue dots.

4 Colour tint the whole ATC using the brown chalk applied lightly with cotton wool.

5 Colour in the images with the watercolour pencils, adding red to the edge of the daisy panel and the 'Life is Beautiful' image. Do not forget to colour the white daisy heads which you have stamped on to the white card.

6 Attach the 'Life is Beautiful' image to the ATC using glue dots.

7 Cut out the daisy heads from the white card, and attach them to your ATC with 3D foam pads.

8 Complete the card using the gold glitter glue applied to the centres of the flowers.

Variations

The Queen

For this ATC I have created a background using acrylic paint. I then stamped the main image directly on to the ATC, and then again on to white card. I cut out the face from the white card and attached this to the ATC.

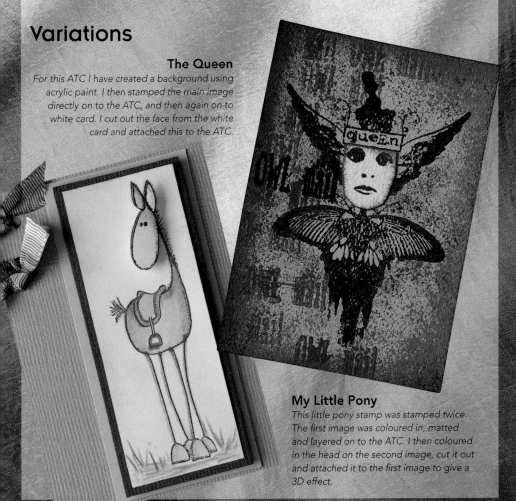

My Little Pony

This little pony stamp was stamped twice. The first image was coloured in, matted and layered on to the ATC. I then coloured in the head on the second image, cut it out and attached it to the first image to give a 3D effect.

Stamping 2

Over-sized stamps can be adapted for ATCs by using shrink plastic. Be careful when colouring the images as when shrunk the colours become more intense and can look too dark for your project.

Young Love

Materials:

'Urban Snapshots: Young Love 2' rubber stamp (PaperArtsy)

'Butcher's Block' paper (DCWV)

Shrink plastic

Sierra Vista chalk inkpad

Saddle Brown solvent-based inkpad

Acrylic stamping block

Brown card

Swirl pattern rubber stamp

Glue dots

Strong all-purpose glue

Tools:

Scissors

Paper trimmer

Heat gun

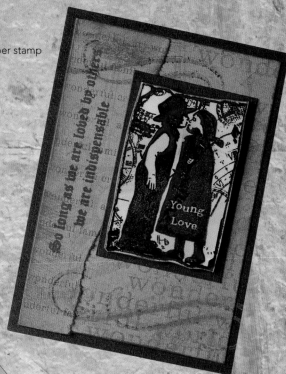

Relax (right)
For this cute ATC I have coloured in the image using water-based felt-tip pens. To lighten the colours and reduce the intensity, I put a little ink on the shrink plastic, then spread the ink over the image using a dry paintbrush.

Instructions:

1 Cut a piece of shrink plastic slightly larger than the 'Young Love' stamp. Drag the chalk inkpad lightly over the shrink plastic to colour tint it. Do not worry if it looks too light as the colour will intensify when the plastic is shrunk.

2 Attach the 'Young Love' stamp to the acrylic block and ink it using the brown inkpad. Stamp the image on to the shrink plastic. Using the heat gun, gently heat the shrink plastic. It will start to fold and shrink, and should flatten out. To make sure it is completely flat, press down on it with the back of the stamping block.

3 When the shrink plastic has cooled, edge the image using the brown inkpad.

4 Cut out a piece of brown card to 6.5 x 9cm (2½ x 3½in), and another piece just larger than the image on the shrink plastic. Attach the shrink plastic to the small piece of card using strong all-purpose glue.

5 Cut down a piece of the Butcher's Block paper and attach it to the card, colour tinting it using the chalk inkpad. Add another coordinating piece of paper to the left-hand side of the card, ripped down one side to create texture. Colour tint the paper using both inkpads.

6 Attach the phrase stamp to the acrylic block and ink it with brown solvent-based ink. Stamp the image down the left-hand side of the card.

7 Stamp the swirl pattern at the top and bottom of the card using the solvent-based inkpad and attach the shrink plastic image.

Variations

Gone Fishing

For this card I have used a fisherman stamp which I coloured in using watercolour pencils and then cut out before it was shrunk. I have used corresponding papers to complete the card.

Stickers 1

For this section I have used a selection of different stickers. Again, the choice is endless so you will always find something you like. I have used peel-offs and paper stickers. If your sticker does not fit, simply trim it down. This will change the look of your sticker and make you look at your project more carefully to see where your sticker looks most effective on your card.

Magenta Magic

Materials:

Peel-off stickers: square-framed floral designs (Magenta)

Gold mirri card cut to 6.5 x 9cm (2½ x 3½in)

Black card cut to 6.5 x 9cm (2½ x 3½in)

Acetate sheet

Sticker machine and permanent adhesive (Xyron)

Gold leaf flakes (tipped into a box with a lid)

Gold leaf pen

Double-sided tape

3D foam pads

Strong all-purpose glue

Tools:

Scissors

Hard brush or scouring pad

Paper trimmer

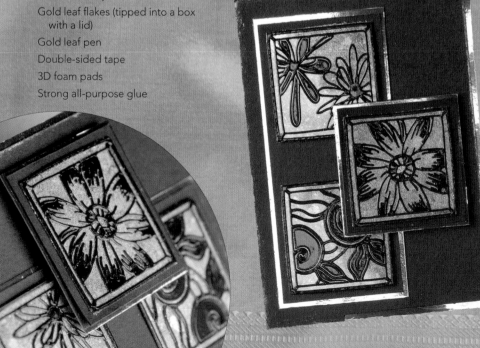

Instructions:

1 Pick three of the peel-off stickers and attach them to the acetate sheet.

2 Cut out the squares and run them through the sticker machine.

3 Peel the squares from the adhesive sheet and press them into the box of gold leaf. The particles of gold leaf will stick to the adhesive. Remove the excess gold leaf using a hard brush or scouring pad.

4 Trim a thin border from one half of the black ATC card and attach it to the piece of gold mirri card using double-sided tape.

5 Cut a rectangle of black card approximately 7.5 x 3cm (3 x 1¼in) and attach two squares to it using strong all-purpose glue (one at the top and one at the bottom). Cut a piece of gold mirri card slightly larger, and attach it to the back of the black card using double-sided tape. Attach this panel to the right-hand side of your ATC.

Variations

Gold Flower
I have used a large peel-off for this card which I have trimmed down so it fits on to the red ATC card. I attached the peel-off using silicone glue.

6 Now attach the third square to a piece of black card cut slightly larger using strong all-purpose glue. Attach this to a piece of mirri card cut slightly larger still, and then attach the complete element to your ATC using 3D foam pads. Position it between the first two squares, on the left-hand side of your card.

7 Finish the card by running the gold leaf pen around the edge.

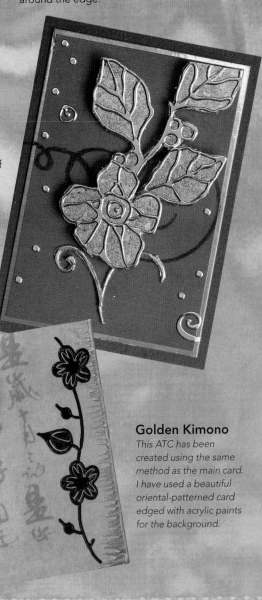

Golden Kimono
This ATC has been created using the same method as the main card. I have used a beautiful oriental-patterned card edged with acrylic paints for the background.

For this section I have used simple ideas using a variety of stickers – again there are so many to choose from. These cards are so simple to make, but look really effective.

Little Bird of Love

Materials:

'Princess Dreamland' stickers
 PDCL196 (Sandylion)

'Cinderella Alphabet' stickers
 PDCL35 (Sandylion)

'Princess Dreamland Meadow' paper
 RMDCL199 (Sandylion)

Blue card cut to 6.5 x 9cm (2½ x 3½in)

White scrap card

Glue dots

3D foam pads

Tools:

Paper trimmer

Scissors

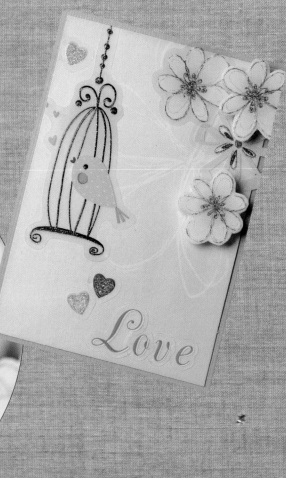

Instructions:

1 Cut a piece of the paper so it is slightly smaller than the blue ATC card. Attach it to the card using glue dots.

2 Peel off the pretty bird in a cage sticker and attach it directly to the top left-hand part of the card. Also attach a pink flower, a blue flower and three small hearts to the card, and spell out the word 'Love' at the bottom.

3 Attach two blue flowers to the scrap card and cut them out. Attach them to the ATC so they overlap the pink and the blue flower using 3D foam pads. Trim off any parts of the flowers that overlap the edge of the ATC.

Variations

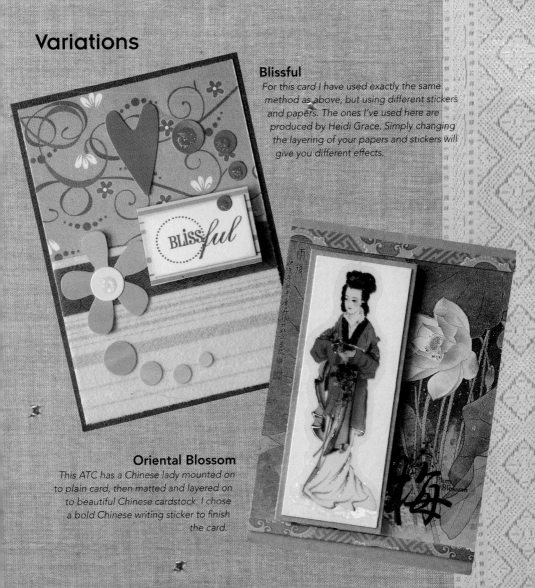

Blissful

For this card I have used exactly the same method as above, but using different stickers and papers. The ones I've used here are produced by Heidi Grace. Simply changing the layering of your papers and stickers will give you different effects.

Oriental Blossom

This ATC has a Chinese lady mounted on to plain card, then matted and layered on to beautiful Chinese cardstock. I chose a bold Chinese writing sticker to finish the card.

Stencils 1

I love stencils, and enjoy the challenge of making an oversized stencil work well on an ATC. On this page I have used spray inks to create the stencilled backgrounds. These are available in packs with coordinating chalk inkpads.

Masked

Materials:

Lavender Tea and Diet Cola spray inks and coordinating chalk inkpads (Memories Mists)

'Primitive Masks' stencils LL538 (Dreamweaver)

Scrap paper

Purple pearlescent card cut to 6.5 x 9cm (2½ x 3½in)

Cream card

Design Runner and Starter Disc (Xyron)

Silver wire

Purple seed beads

Double-sided tape

Tools:

Scissors

Paper trimmer

Instructions:

1 First cut the cream card slightly smaller than ATC size. Create your background by spritzing it with the Lavender Tea spray ink, then a small spritz of Diet Cola. When dry, place the stencil on the card, cover the surrounding area with scrap paper and spritz again with the Lavender Tea and a little of the Diet Cola. Carefully remove the stencil, reposition it so it overlaps the first, and repeat. Vary the intensity of the spritz to get different results. (Do not clean the stencil: take a piece of scrap card and place it over the stencil to soak up the ink – this image can then be used to create another design, as on the card below.)

2 Allow to dry, then use the Lavender Tea chalk inkpad to edge the sides of your card.

3 Add the word 'escape' to the top and bottom of the card using the Design Runner.

4 Wrap a length of wire around the card, twisting it and threading on a few purple seed beads as you work.

5 Allow parts of the wire to be wrapped around the back of the card, securing it with double-sided tape at the back. This will help hold the wire in place when you attach it to the purple pearlescent card.

6 Attach the purple card to the back of the stencilled design.

Variations

Beautiful Ferns

This ATC has been created using the same technique but with a fern stencil and green spray inks. It is simply finished with a clear sticker which allows the beautiful design to show through.

A *friend* may well be reckoned the *masterpiece* of nature.

Ralph Waldo Emerson

Escape

This ATC has been made from the card used to soak up the ink in the main project! I have simply trimmed it down and then edged the card with the Diet Cola chalk inkpad. To complete the card I have added the word 'escape' across one corner, layered on to card, and two decorative bows.

Stencils 2

Embossing paste is a fantastic way to create raised, textured images using brass stencils. It is available in a range of colours, and can be trimmed down when dry to fit your ATC.

Floral Background

Materials:

'Floral Pattern' brass stencil
 LG631 (Dreamweaver)
Metallic gold embossing paste
Red pearlescent card cut to 6.5 x 9cm
 (2½ x 3½in)
Magnolia pearlescent card
Gold mirri card
Red adhesive stones
Scrap paper
'Simple Thoughts – Life' quote stickers
 (Cloud 9 Design)
Double-sided tape
3D foam pads
Strong all-purpose glue
Low-tack masking tape

Tools:

Paper trimmer
Scissors
Lollypop stick or spatula

Instructions:

1 Cut the magnolia pearlescent card down to approx 8 x 5.5cm (3¼ x 2in). Stick it to a piece of scrap paper with low-tack tape, then place the stencil over the top, again sticking it down on the scrap paper with low-tack tape.

2 Smooth the embossing paste over the top of the stencil using a lollypop stick or spatula; make sure the paste completely fills the stencil. Carefully lift off the stencil and leave the paste to dry overnight (wash your stencil immediately).

3 Trim the gold mirri card so that it is slightly smaller than ATC size, and attach it to the red pearlescent card using double-sided tape.

4 When the paste has dried, attach the stencilled card to the mirri card in the same way.

5 Peel off a quote sticker and attach to a small piece of pearlescent card. Trim it to leave an even border, and then attach this to a small piece of mirri card using 3D foam pads. Attach this to the card using strong all-purpose glue.

6 To complete the card attach red stones to the centres of the open flowers.

Variations

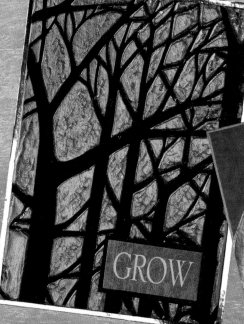

Trees

For this card I have used a beautiful tree stencil; it is a large stencil but is very effective at ATC size. I have kept the design simple, and finished the card with a 'grow' word sticker. I created extra texture by moulding it gently with the lollypop stick while the paste was still wet; it then dried with an uneven surface.

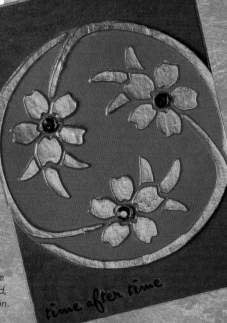

Circle of Life

This card has been completed using a circular stencil, which I have trimmed slightly so it fits on to the ATC. I have used lightly patterned background card, and finished the card with a small rub-on.

Decorative papers 1

Striking ATCs can be made using decorative papers. Apart from those designed specifically for papercrafting, there are numerous other types of papers you can use such as wallpaper, sweet wrappers, and labels from jars and bottles – simply use your imagination! On this page I have picked a variety of wallpapers as I love the different textures they offer and the wide array of colours and patterns available.

Big Pink Flower

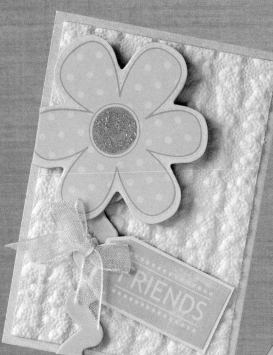

Materials:

Pink pearlescent card cut to
 6.5 x 9cm (2½ x 3½in)
White textured wallpaper
'Friendship' chipboard flowers
 (Creative Imaginations)
'Friends' designer sticker PP01
 (Melissa Frances)
Iridescent glitter glue
White ribbon
Small 3D foam pads
Double-sided tape
White scrap card

Tools:

Paper trimmer
Scissors

Instructions:

1 Trim down the piece of wallpaper so that it is slightly smaller than the ATC, and attach it to the ATC using double-sided tape.

2 Peel off the wavy line sticker from the sheet and trim it down to approximately 6cm (2¼in) in length. Wrap a piece of white ribbon around it and tie it in a bow. Attach it to the left-hand side of the card (the sticker is self-adhesive).

3 Attach a chipboard flower to the top of the wavy line – I put small 3D foam pads on three of the petals to raise it off the surface. Trim off any parts of the petals that overlap the edge of the card.

4 Peel off the 'Friends' tag and attach it to a small piece of white card. Trim around this carefully to leave an even white border around the sticker.

5 Attach the tag to your card, tucking it just underneath the bow and sticking down with double-sided tape.

6 Complete the card using glitter glue applied to the centre of the flower.

Variations

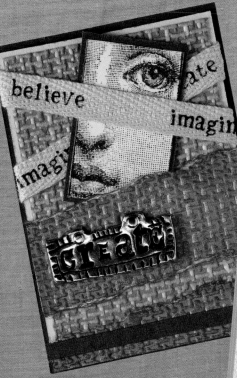

In the Blue
This card was made using small coloured sections of wallpaper placed on top of a piece of white wallpaper, and completed with small peel-off words and a pretty flower.

Create
For this ATC I have used textured wallpaper again as my background, but also torn it and painted it using acrylic paints to emphasise the texture. I then added ribbon, stamped images and charms to complete the card.

Decorative papers 2

On this page I have used papers designed specially for papercrafters. For the ATC below I have chosen a double-sided paper which has a pattern that is easy to decoupage. It is very easy to make and uses only one piece of paper, with a few decorative accents.

Pretty in Blue

Materials:

30.5 x 30.5cm (12 x 12in) paper from 'Trend' Paper Pad to Go (K & Company)

Iridescent glitter glue

Adhesive diamonds

3D foam pads

Metallic silver-coloured pigment inkpad

Glue dots

Tools:

Paper trimmer

Scissors

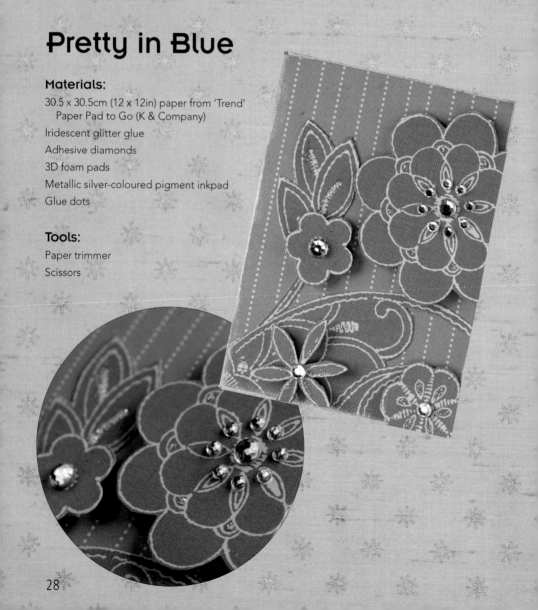

Instructions:

1 Cut a piece of the paper to 6.5 x 9cm (2½ x 3½in) and edge it using the silver-coloured inkpad.

2 Trim a piece of paper along one of the stems of the flowers so that it fills just over a third of the bottom part of your card.

3 Cut out four flowers and position them on the card, but don't stick them down at this stage. To create more space on the card, I allowed three flowers to 'fall off' the edge. Trim off the parts of the flowers that overlap the sides of the card.

4 Attach the flowers to the card using 3D foam pads, and then complete the card with adhesive diamonds and a little glitter glue to give it sparkle.

Variations

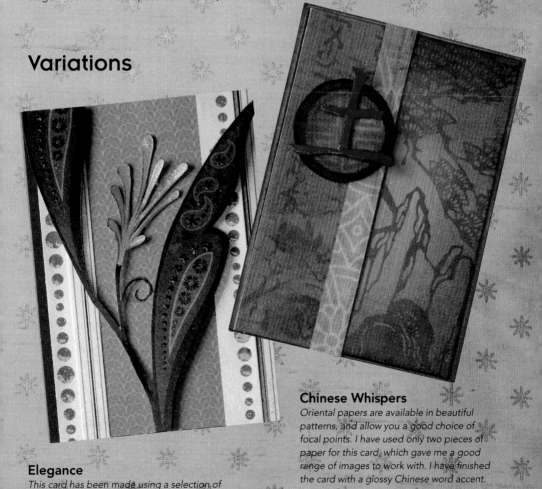

Chinese Whispers
Oriental papers are available in beautiful patterns, and allow you a good choice of focal points. I have used only two pieces of paper for this card, which gave me a good range of images to work with. I have finished the card with a glossy Chinese word accent.

Elegance
This card has been made using a selection of papers by Heidi Grace. This time I have used a variety of background papers but chose only one main focal image which I attached with silicone glue to bring it forward.

29

A touch of metal 1

Metal, in the form of brads, eyelets and wire, can be used to embellish ATCs to great effect. Here I have combined it with polymer clay – a highly creative medium that works well with metal elements. Always use wire that is easy to work with and pliable.

Oriental Elements

Materials:

Black card cut to 6.5 x 9cm (2½ x 3½in)

Silver mirri card

White card

Silver wire

Black polymer clay

Metallic silver-coloured pigment inkpad

'Asian Character Background' rubber stamp G-PSH040 (Stamp n' stor)

Asian design clear sticker

Double-sided tape

Strong all-purpose glue

Tools:

Paper cutter

Scissors

Oven

Friend (right)
The polymer clay face and the word 'Friend' have been created using a push mould. I attached the polymer clay to a small sheet of metal mesh, and baked it. I then threaded wire through the mesh, adding seed beads at regular intervals. After baking, I applied a colour tint to the polymer clay.

Instructions:

1 Soften and roll a piece of black polymer clay so it is flat.

2 Ink your Asian stamp with the silver inkpad and stamp into the polymer clay, applying enough pressure to create an indent. Cut the clay into different sized squares and thread them on to wire, bending and coiling the wire so that the squares overlap. Insert a short length of wire into the bottom square and attach a small, slightly flattened ball of clay to the end. Similarly, thread a length of wire through the top square and attach a ball of clay on each end. Put the whole piece into the oven and bake it, following the manufacturer's instructions. Allow the clay to cool in the oven.

3 Cut a piece of silver mirri card slightly smaller than ATC size and attach it to the black card using double-sided tape. Cut the white card down so it is smaller than the silver mirri.

4 Drag the silver-coloured inkpad round each edge of the white card to give it a silver border.

5 Ink the Asian stamp just around the edge and stamp the image on to the white card (only the outer part of the image will be transferred).

6 When the polymer clay has cooled, attach it to the white card using strong all-purpose glue and allow the glue to dry.

7 To complete the card, attach a small Asian sticker to the bottom left-hand corner.

Variations

Timeless Flowers

This ATC is made using a cane of polymer clay in which the flower pattern has already been created. I have cut four squares, which I have threaded together with finer silver wire, baked and allowed to cool, then applied a little clear nail varnish to give a gloss finish.

A touch of metal 2

For this section I have used brads and eyelets, for which you will need pricking and eyeletting tools. Brads and eyelets are both decorative and practical, allowing vellum and acetate to be attached to your ATCs without having to use adhesive.

Romance

Materials:

Pink card cut to 6.5 x 9cm (2½ x 3½in)

White card

Pink brads

Small silver brad

Vintage collage and transparency images, Picture Pack 005 (PaperArtsy)

'Winged Heart' charm (PaperArtsy)

'Pastel Words' 0761 (Tim Holtz)

Double-sided tape

Glue dots

Pink chalk inkpad

Tools:

Paper cutter

Scissors

Pricking tool

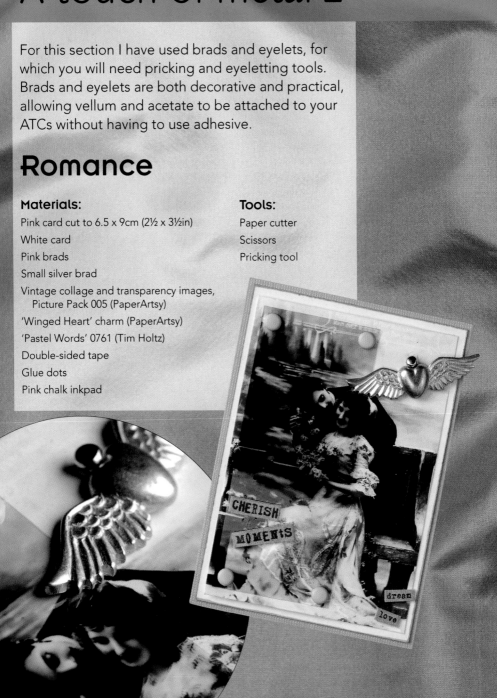

Instructions:

1 Cut the white card slightly smaller than the pink ATC. Trim down the collage sheet so that it will fit on to the white sheet. Do not attach any of the layers together yet.

2 Cut down the transparency sheet so that it covers only the left-hand side of the collage sheet. Lay the transparency sheet directly over the collage sheet and put a hole through both in each corner. Push a pink brad through each hole and open up the legs at the back.

3 Make a hole in the right-hand part of the collage sheet and place a small silver brad through the charm and the sheet, again opening the brad at the back to secure it.

4 Using the pink inkpad, edge each side of the white card. Attach the collage sheet to the white card using double-sided tape, then attach this to the pink card.

5 To complete the card, cut out words and attach them to the ATC using glue dots. (Hold a length of glue dots with one hand, put the small pieces of card on to the adhesive and then peel them off; this is easier than having small pieces of card on your work surface and attempting to put the glue dots on top.)

Variations

Paisley Elegance

For this card I have used eyelets to hold down vellum, thereby avoiding any adhesive showing through. The vellum matches the gold paisley peel-offs, and the eyelets complement them perfectly.

Vellum Daisies

For this ATC I have used brads to hold down vellum flowers, which I have made by stamping and embossing on to vellum. Using brads in this way looks attractive, and avoids having to use unsightly adhesive.

Embellishments 1

Initially I did not know where to start with embellishments; my craft room is over-flowing with a fantastic range of products. I thought I would start with beads, as I have always loved them and do not get the chance to work with them as much as I would like.

Beads, Beautiful Beads

Materials:

Brown card cut to 6.5 x 9cm (2½ x 3½in)
Copper mirri card
Cream card
Vintage Photo distress inkpad (Tim Holtz)
Sponge
Clear beading thread
Selection of complementary beads
Large floral feature bead
Crimp beads
Gold jump ring
Double-sided tape
Glue dots
Silicone glue
Design Runner and Starter Disc (Xyron)

Tools:

Scissors
Paper trimmer
Flat-nosed pliers

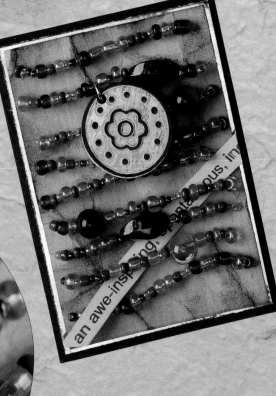

Instructions:

1 Cut the mirri card slightly smaller than ATC size, and the cream card slightly smaller still.

2 Scrunch up the cream card and then flatten it. Brush over it lightly with the distress inkpad, catching only the raised areas of the card. Blend the wet ink into the rest of the card with a sponge.

3 Cut a small 'nip' into the side of the cream card near the top. Attach a length of thread at the back of the card with double-sided tape and start to thread on the beads in a random pattern. When you have threaded on enough beads to reach the other side of the card, stop, and wrap the thread around the back of the card. Repeat, until you have worked your way down to the bottom of the card. Secure the thread on the back of the card.

Variations

4 Add a large floral bead using a jump ring.

5 Print off a phrase using the Design Runner, and stick it down using glue dots and a little silicone glue to raise one end.

Chinese Flower

Just five small beads have been used to finish off this oriental-style card. I have used the clear beading thread and double-sided tape to attach them to the back of the card.

Tree Spirit

I have owned this lovely little pendant bead for years, so I eventually decided to use it on an ATC. I have added a couple of jump rings to the flower bar and attached them to the card using two silver brads. Use a swirl-patterned stamp to create a mystical background.

Embellishments 2

On this page I have used charms to embellish the ATCs. These come in a wide variety of designs and can really bring your card to life.

Funny Folk

Materials:

Plain cream card cut to 6.5 x 9cm (2½ x 3½in)

Hat, legs and hands charms (PaperArtsy)

Dot pattern rubber stamp (Hampton Art – Diffusion)

'Double Heart Flowers' rubber stamp F4609 (Hero Arts)

Brown printed ribbon 12-71530 (Heidi Grace)

'Wings and Things' cuttable strip (Tim Holtz)

20.5 x 20.5cm (8 x 8in) paper from 'Once Upon a Time' stack PS006-00013 (DCWV)

'Pastel Words' 0761 and 'Light Words' 0756 (Tim Holtz)

Small silver brads

Brown mixed-fibre wool

Spiced Marmalade and Vintage Photo distress inkpads (Tim Holtz)

Double-sided tape

Silicone glue

Glue dots

Strong all-purpose glue

Tools:

Paper trimmer

Scissors

Pricking and picking-up tool

Nail file

Instructions:

1 Attach the hat charm to the top of the card in the centre using a small silver brad. Cut around the hat, then down to each bottom corner in a gentle curve to form the body.

2 Glue a piece of paper from the 'Once Upon a Time' stack to the body, and trim to the same shape.

3 Randomly stamp dots using the 'Spiced Marmalade' ink over the body, then stamp the flower using 'Vintage Photo' on the right-hand side.

4 Attach a piece of ribbon across the centre of the body, wrapping it around the sides, using double-sided tape.

5 Cut out the wings from the cuttable strip and attach them to the back of the body using glue dots.

6 Using small silver brads, attach the legs and arms to the body. (Do not worry about the legs making the ATC longer than it should be, as they can be folded in.) Glue wool under the hat, then glue down the hat.

7 To complete the card, cut out some words and roughen the edges using the nail file. Stick them on to the card using glue dots and silicone glue.

Variation

Little ATC Book

This ATC is made in the form of a book. The hinges are beautiful vintage charms. I have decorated the card using coordinating papers, tags, ribbons and buttons from Hot Off The Press.

Memorabilia 1

Dig out your old photographs, postcards, sweet wrappers, cinema tickets – anything that holds a memory of a time or a place. If you do not want to use an original use a copy, and make personal ATCs. You could even put a piece of journaling on the back to share your memories with the recipient.

Bondi

Materials:

Postcard

'Simple Thoughts – Travel' quote stickers (Cloud 9 Design)

White 'Daydream' rub-on doodles ST-009-00001 (DCWV)

'Light Words' cuttable strip (Tim Holtz)

Clear dimensional gloss medium (Glossy Accents)

Black pigment-based inkpad

Embossing inkpad

Silver embossing powder

Glue dots

Silicone glue

Tools:

Heat tool

Paper trimmer

Scissors

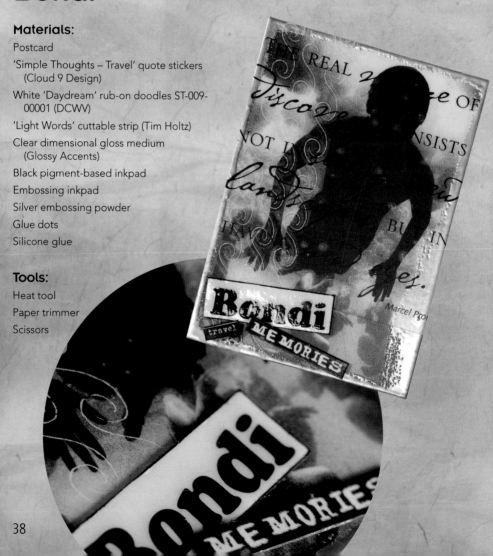

Instructions:

1 Cut down your postcard to 6.5 x 9cm (2½ x 3½in).

2 Run the embossing inkpad round the edge of the card and dip each edge into a line of silver embossing powder. Heat the powder until it melts.

3 Cut out the waves line from the rub-on sheet and rub three lines of waves on to the left-hand side of your card.

4 Stick the large 'discovery' sticker directly over the top of your ATC.

5 I have taken the word 'Bondi' from the back of the postcard, edged it using the black inkpad, then attached it to the card using glue dots. Alternatively, choose a word from the cuttable strip.

6 Cut out two words that complement your card from the cuttable strip (I chose 'memories' and 'travel'). Attach one using glue dots and the other using silicone glue so you can overlap the word 'Bondi'.

7 Complete the card by adding dimensional gloss medium over the word 'Bondi', and leave it to dry.

Variations

Blackpool

This postcard was too precious to use the original, so I photocopied the front and back, then took parts of the back of the postcard to decorate the front. I have used distress ink (Vintage Photo), to colour tint the card, and added a pretty brad to complete it.

Watch Cottage

This is my mum's favourite place, so I used an original postcard from her to create this card. Simply trim the card down, use a nail file to age the edges of the card, and add a postage stamp as part of the decoration. I printed the words 'Watch Cottage by Alun Davies' on the computer.

Memorabilia 2

I have used old family photographs in this section. Using Fo2fuse film allows you to transfer a printed image on to various bases, and to colour it – experiment, and see what fantastic effects you can achieve!

Uncle Tom

Materials:

Photograph
Black glossy card cut to 6.5 x 9cm (2½ x 3½in)
Cream card
Scrap card
White cotton fabric
Black sewing thread
Fo2fuse film
Double-sided tape

Tools:

Printer
Paper trimmer
Sewing needle
Scissors
Craft knife
Hard paintbrush
Scanner (if you need to scan in your photograph)

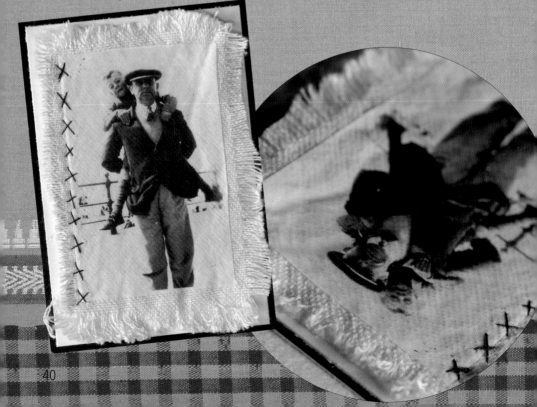

Instructions:

1 Scan your photograph if you do not have it on your computer already, then print it out on to your Fo2fuse film (following the manufacturer's instructions).

2 Create a frame for the photograph using scrap card and attach it to the front of the photograph with double-sided tape leaving a 2mm (1/16in) border all round.

3 Cut a piece of fabric slightly smaller than ATC size. Peel off the back of the film then lay the picture in the centre of the fabric so the picture is facing you.

4 Gently cut round the edge of the frame using a craft knife, and lift the frame off the picture. Rub the picture into the fabric using a hard paintbrush (the film will pick up the texture of the material as you rub).

5 Trim down the cream card so it fits on to the black ATC leaving a neat border (do not attach it to the ATC card yet). Fray the fabric and attach it to the cream card using double-sided tape.

6 Sew a line of cross stitching down the left-hand side of the card using black thread.

7 Attach the cream card to your black ATC card using double-sided tape.

Variations

Our Rob

I have used Fo2fuse again to make this ATC, but this time on a smooth base. I have simply added blue and green acrylic paint to finish the card.

Picture This

For this little picture I have printed off a photograph and captured it in a pretty metal frame. Different layers of paper, a pretty ribbon and the 'family' embellishment complete this ATC.

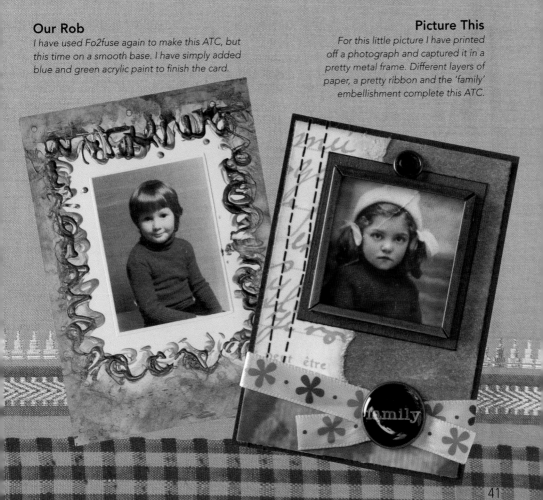

Taking it further 1

Virtually any papercrafting or cardmaking technique can be downsized and applied to ATCs to make them just as fun and interesting as greetings cards! On this page, I have used pre-cut ATCs to create jigsaw cards.

Dream Card

Materials:

Pre-cut jigsaw card (Crafty Bitz)

Sea Breeze and Hint of Pesto chalk inkpads

Rose Pink and Light Green water-based felt-tip pens

'Bamboo' rubber stamp H-PSH011 (Stamp n' Stor)

'Little Flower' rubber stamp B-PSH011 (Stamp n' stor)

White scrap card

Iridescent glitter glue

3D foam pads

Glue dots

'Far East' chipboard sticker stack (DCWV)

Tools:

Scissors

Instructions:

1 Colour tint the jigsaw card by applying the Sea Breeze chalk inkpad directly to the paper. Colour both sides of the flaps and the inside only.

2 Ink up the bamboo stamp with the Hint of Pesto inkpad and stamp over the coloured parts of the ATC.

3 Colour in the flower stamp using the felt-tip pens (pink for the petals and green for the leaves) and stamp it three times on the white scrap card. Next just colour in the pink flowerhead and stamp another five times. Cut out all eight images.

4 Decorate the front of the flaps using five of the flowers (two full flowers and three flowerheads), placing some straight on to the card using glue dots, and others raised on 3D foam pads to create depth.

5 Inside the card attach the 'Dream' chipboard sticker on the right-hand side, then decorate it with the remaining flowers.

6 Finish the card with a little glitter glue placed in the centre of the flowers.

Variation

Giggle

This ATC has been created by simply layering papers from the 'Sunshine' ATC kit (Crafty Bitz) and adding cardboard cut-outs and rub-ons. A few Glossy Accents and some glitter glue have been used to finish.

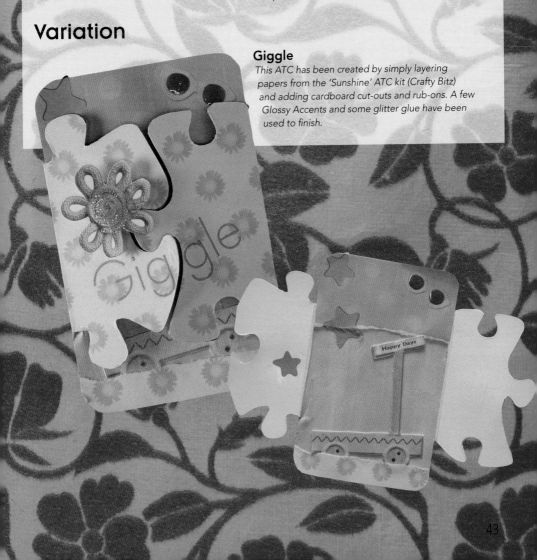

Taking it further 2

Pocket cards can be bought ready-made, and give you plenty of scope to be creative as you have the front, back and tags to decorate.

A Pocketful of Proverbs

Materials:

Pocket card (Crafty Bitz)

'Seaside Stripe', 'Seaside Vine' and 'Seaside Poppy' papers (Scrapworks)

'Seaside' canvas tabs and canvas ribbon (Scrapworks)

'Seaside' puzzle pieces (Scrapworks)

Proverbs to Go 310056 (K & Company)

Coordinating paper flower and proverb (K & Company)

Glue dots

3D foam pads

Thin double-sided tape

Silicone glue

Tools:

Scissors

Paper trimmer

Front *Back*

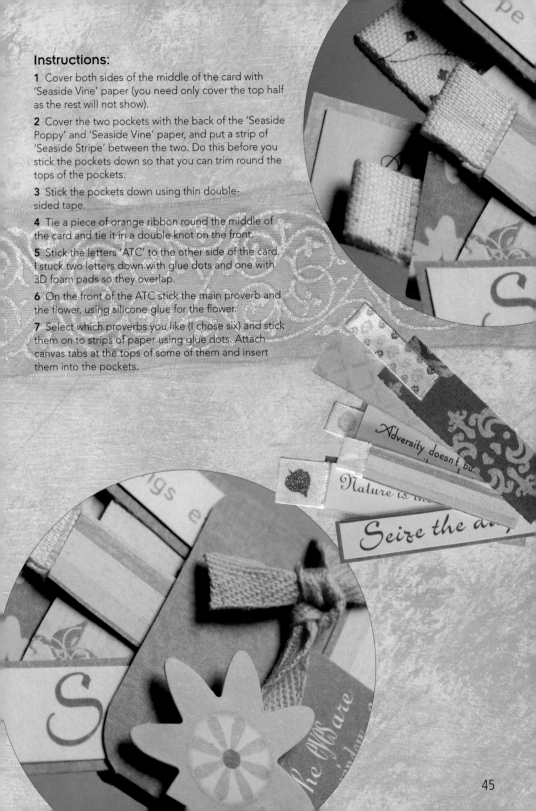

Instructions:

1 Cover both sides of the middle of the card with 'Seaside Vine' paper (you need only cover the top half as the rest will not show).

2 Cover the two pockets with the back of the 'Seaside Poppy' and 'Seaside Vine' paper, and put a strip of 'Seaside Stripe' between the two. Do this before you stick the pockets down so that you can trim round the tops of the pockets.

3 Stick the pockets down using thin double-sided tape.

4 Tie a piece of orange ribbon round the middle of the card and tie it in a double knot on the front.

5 Stick the letters 'ATC' to the other side of the card. I stuck two letters down with glue dots and one with 3D foam pads so they overlap.

6 On the front of the ATC stick the main proverb and the flower, using silicone glue for the flower.

7 Select which proverbs you like (I chose six) and stick them on to strips of paper using glue dots. Attach canvas tabs at the tops of some of them and insert them into the pockets.

Variations

Time Goes By

This ATC has been made using the components of the 'Memories' ATC kit (Crafty Bitz), together with a chalk inkpad to edge the papers. I chose the rub-ons 'Who?' and 'When?' for my little tags.

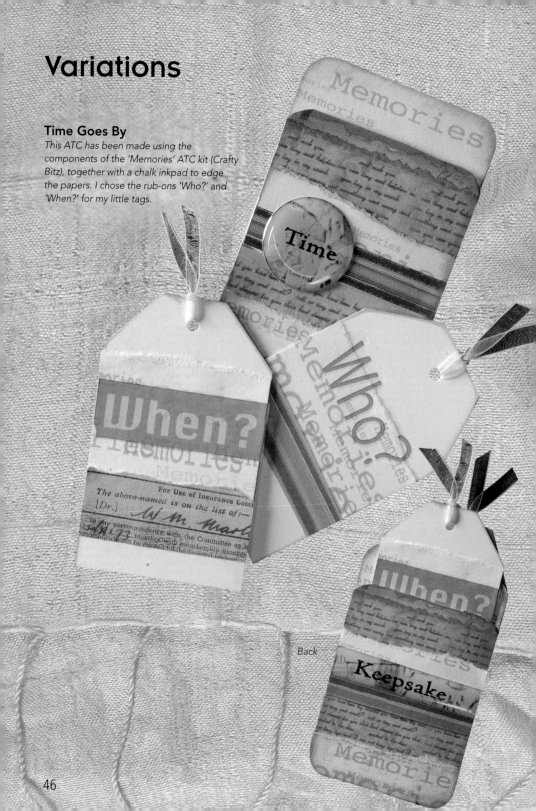

Back

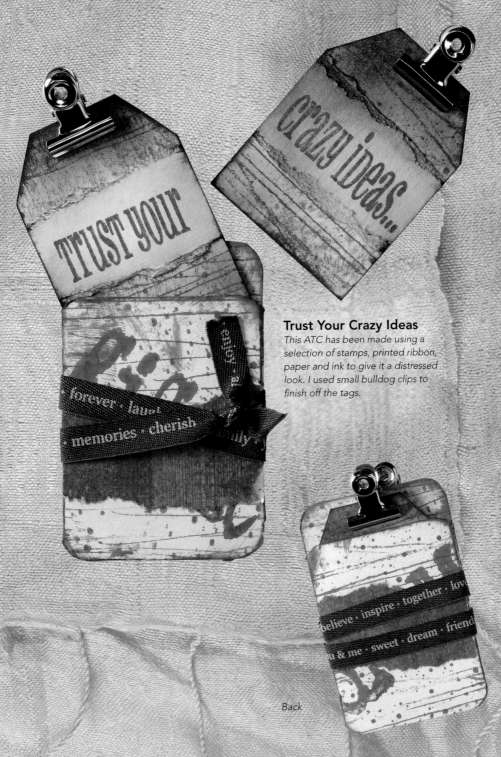

Trust Your Crazy Ideas

This ATC has been made using a selection of stamps, printed ribbon, paper and ink to give it a distressed look. I used small bulldog clips to finish off the tags.

Back

Acknowledgements

I would like to express my gratitude to the following people for their help, and for supplying fantastic products for me to create the ATCs in this book:

Dawn, Rena and everyone at Topaz Crafts; Judith at Woodware; Leandre at PaperArtsy; Gill at All About Crafts and Sara at Hot Off The Press.

I would also like to acknowledge the following companies whose fantastic products have also been used:

Amaco; Cloud 9 Design; Crafty Bitz; Creative Imaginations; Die Cuts With a View (DCWV); Deja View; Design Objectives; Dreamweaver; Fimo; Fo2fuse; Hampton Art Stamps; Heidi Grace; Hero Arts; House Mouse; K & Company; Magenta; Marij Rahder; Melissa Frances; Papermania; Paper Plus/Pattern Builder; Personal Impressions; Posh Ltd/Stamp n' Stor; QuickKutz; QVC; Ranger; Sandylion Sticker Designs; Scrapworks; Stampboard; Stewart Superior/Memories Mists; Tim Holtz; Xyron.

Also thank you to Katie and Roz for their help and patience in publishing my first book, also to Debbie the photographer who made everything look so good!

Every attempt has been made to contact companies whose products and/or designs have been used in this book, but in some cases this has not been possible. The author and Publishers hope to have acknowledged all the relevant companies, and to any who have been inadvertently left out we offer our sincere apologies.